PERIQUE

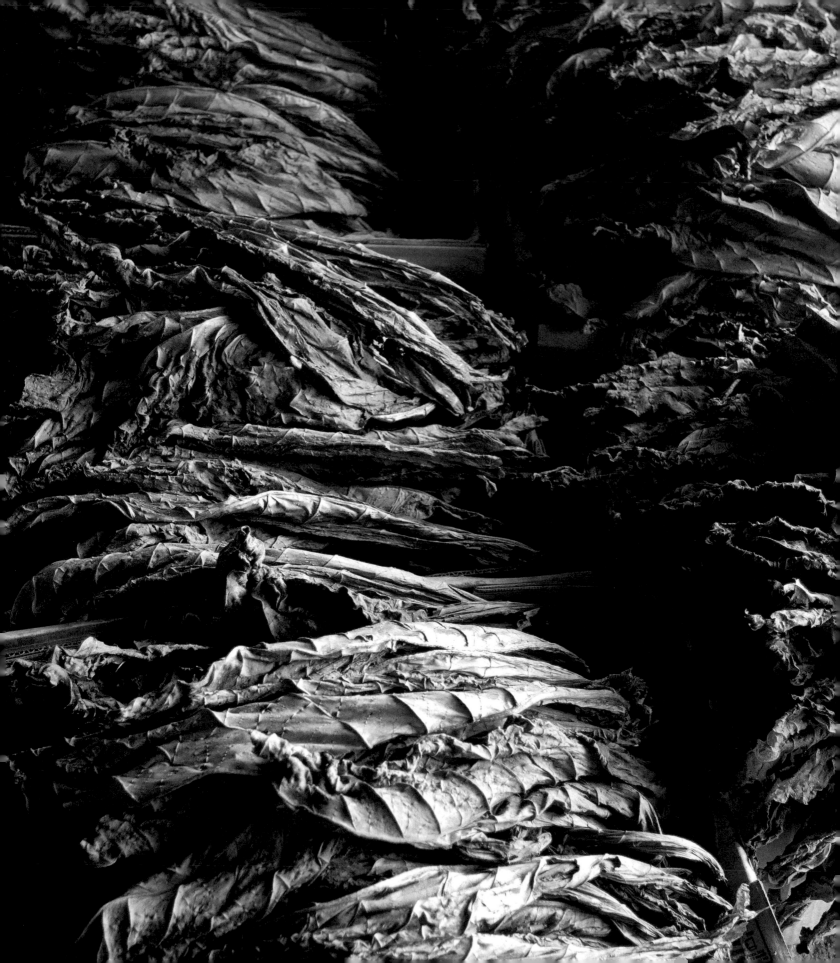

PERIQUE

PHOTOGRAPHS BY CHARLES MARTIN

with essays by Mary Ann Sternberg & John H. Lawrence

THE HISTORIC NEW ORLEANS COLLECTION

2012

THE HISTORIC NEW ORLEANS COLLECTION
*is a museum, research center, and publisher dedicated to
the study and preservation of the history and culture of
New Orleans and the Gulf South region. The Collection
is operated by the Kemper & Leila Williams Foundation,
a Louisiana nonprofit corporation.*

Published on the occasion of the exhibition
Perique: Photographs by Charles Martin at
The Historic New Orleans Collection,
November 29, 2012–February 2, 2013

533 Royal Street
New Orleans, Louisiana 70130
www.hnoc.org

Project editor: *Dorothy Ball*
Senior editor: *Sarah R. Doerries*
Director of publications: *Jessica Dorman*
Executive director: *Priscilla Lawrence*
Catalogue design: *Tana Coman*

First edition. 1,500 copies.
Printed in New Orleans by Garrity Print Solutions

16 15 14 13 12 1 2 3 4 5

ISBN-13: 978-0-917860-62-1
ISBN-10: 0-917860-62-4

Library of Congress Control Number: 2012038729

PHOTOGRAPHS BY CHARLES MARTIN

PERIQUE TIN ON PAGE 13 COURTESY TANA COMAN,
PHOTOGRAPH BY KEELY MERRITT

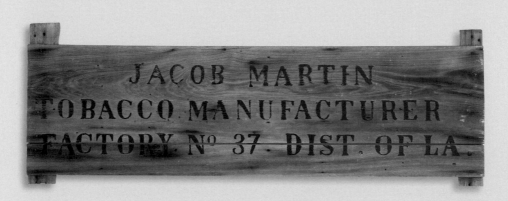

HUMBLE, HONEST, SPIRITUAL—

a description of my grandfather, Jacob Martin Sr.
A center point of community, dedicated to family, he was the quality of man
who sowed the seeds that made our country the great place it is today.
I dedicate this book to him; he was one of the finest.

CONTENTS

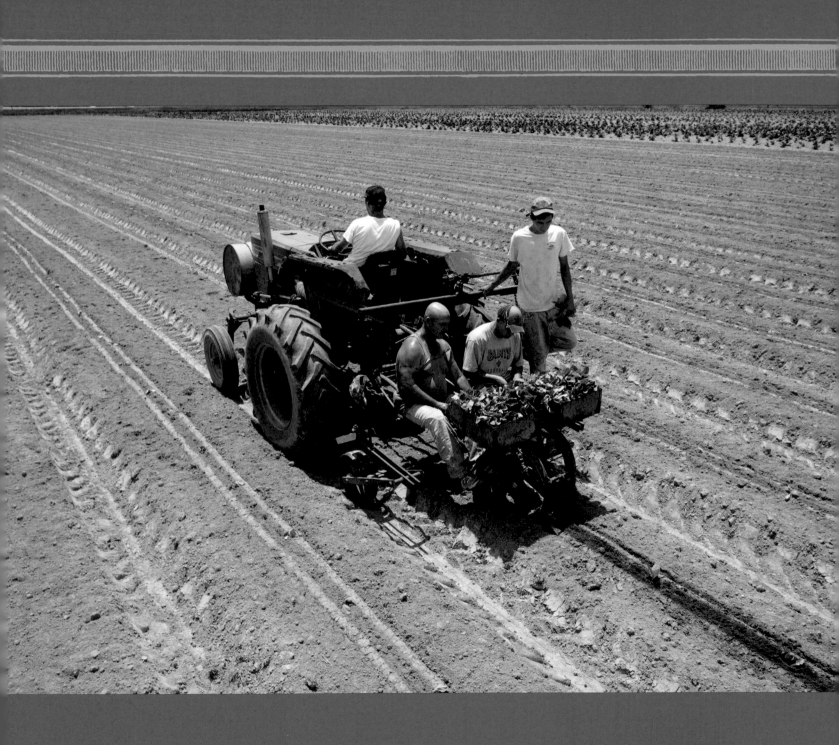

FOREWORD

PERIQUE TOBACCO is both a product and a process, unique to a tiny patch of land hard by the Mississippi River in St. James Parish. This tobacco's pungent characteristics make it a desirable blending tobacco the world over, and every last shred of it is grown and cured by a small number of families, using techniques practiced in the area since the 1820s. Over the centuries, some of the tools have changed—plastic barrels have, in part, replaced wooden ones, and a bit of mechanization has crept into some aspects of growth and manufacturing that earlier had been the been the domain of farm animals—but the process itself has been as durable as the arpent lines on the landscape whose soil gives the leaf its special characteristics.

Charles Martin (b. 1961), from a family of perique farmers, felt compelled to document this unique industry at a time when some farmers still work with the same tools that have been in use for decades. It is not just the access that he has to the seasonal cycle of growth and production that gives merit to his pictures, but his reverence for the historical nature of his subject and those earlier generations who worked the same land. The push and pull of the seasons, from outside to indoors, from bustling activity to quietly biding time are all present in this series of photographs. They are documentary in content and style, as well as expressions of the personal history of their maker. In the parlance coined by the late John Szarkowski, they are both a mirror and a window.

The future of Louisiana's perique farms and producers is unknown. Yet this series of photographs will always attest to the vision of a privileged witness and a reliable interpreter of the subject.

—*John H. Lawrence, director of museum programs*

APPROXIMATELY 2,500 TOBACCO SEEDLINGS ARE PLANTED PER ACRE.

9

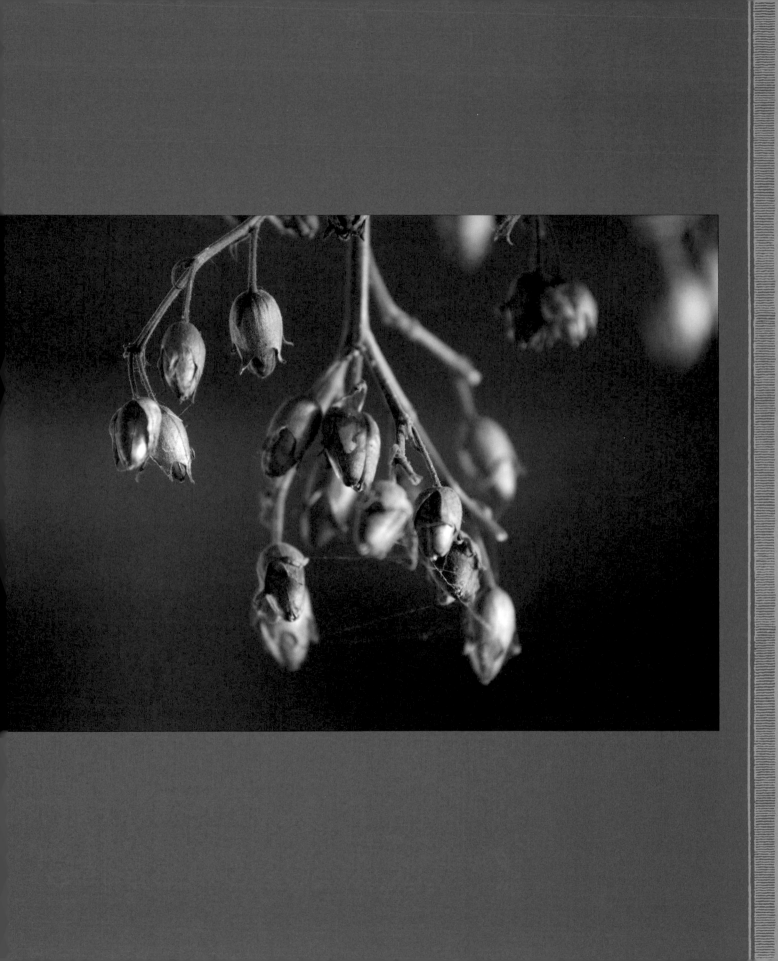

PERIQUE A LEGEND, A TRADITION, AND A NEW CHAPTER

by Mary Ann Sternberg

LITTLE IS KNOWN about Acadian farmer Pierre "Perique" Chenet beyond a few facts: he lived from 1758 to 1837; he and his wife had twelve children; he was an avid hunter and trapper; and he created a world-famous product that immortalized his nickname. In 1824, on the east bank of St. James Parish, Chenet began a small enterprise selling pressure-fermented tobacco, a product created by a special process he was said to have learned from Native Americans and sold as "*le tabac de perique.*"

Though perique is not well known today, it was long considered one of Louisiana's premier products. An 1875 *Daily Picayune* article extolled its virtues: "Not even sugar and cotton are more famous as productions of Louisiana than this justly celebrated tobacco," the newspaper crowed after perique entries won awards at international expositions in Paris and Vienna. "Wherever there are connoisseurs of the weed, it is known and esteemed as its great merits deserve." Touted as "the champagne of tobaccos" in a 1915 book about American tobacco, perique was noted for its rich, fragrant aroma and spicy sweetness, both attributed "not to any peculiarity in the leaf itself" but rather to the curing and fermentation process. Well into the twentieth century,

perique remained a valued component of pipe blends and specialty cigarettes.

The story of perique is awash in local color and deep tradition. It is believed, for example, that perique will grow only in a small alluvial triangle on the east bank of St. James Parish, due to geology, soil, and other undefined properties—the *terroir* provided by this special patch of land. The triangle's base runs between the River Road towns of Paulina and Belmont; its apex lies at Grand Point, a tiny community surrounded by swamp and too small to make Google maps. Attempts through the years to grow perique elsewhere, even in conditions deemed similar enough to be promising, have never yet been successful.

Perique's success in this rural flatland might be explained as much by sociology as by geography. The perique business has historically been a family business, a labor-intensive enterprise involving individual families, in which several generations have participated in each step of the hands-on process. There was great advantage in having family members—with the aid of willing friends and neighbors—working together, planting and transplanting, stripping and curing. Each generation

PERIQUE SEED PODS ARE HUNG TO DRY.

passed its secrets along to the next, which allowed aficionados to swear that producing a fine perique was like trying to make the perfect gumbo—an art form.

The perique cycle traditionally begins in late December or early January, when the seeds—so tiny, it is said, that a hundred thousand could fit into a Cajun lady's sewing thimble—are planted in protected beds, inside sheds or greenhouse-like structures. Originally the seedlings were further shielded from the nightly chill by a covering of palmetto leaves or grass; in modern times plastic sheeting is the covering of choice. Exposed each morning to the sunlight and warmth of the day, the best of the seedlings are transplanted into prepared fields by hand when they reach a height of approximately four inches—typically in March, when the danger of frost has passed. Then farmers begin tending the crop with the watchfulness that accompanies every agricultural venture, protecting the plants from disease, insects, drought, and deluges. Before the plants reach maturity, workers march through the field and pinch off suckers—the top growth from each tobacco plant—to encourage larger, fuller leaves at the bottom of the stalk.

The approximately ninety-day growing season culminates in the harvest (called *fabrique*), which takes place during the sweaty months of June and July. Farmers hack the base of each stalk with a machete or cane knife and leave the stiff, forest-green leaves to wilt overnight on the row. In the morning, the stalks are collected and taken to a barn, where the base of each is pierced with a nail and hung to dry, typically for a couple of weeks. Once the leaves reach the proper brown limpness, they are removed, moistened, and heaped before a party of workers—traditionally women and children—who devote days to the ritual of stripping the leaves from the stems and tying bunches of leaves into bundles, which the men then pack into fermenting barrels.

According to legend, Pierre Chenet had learned this process by watching Choctaws and Chickasaws cultivate and cure their tobacco. The natives packed tobacco leaves into a hollowed-out stump, which was covered with a heavy cypress weight. The weight was placed under pressure by using a lever fashioned from a cut sapling positioned in a crotched tree. Pressure from the lever squeezed juice from the tobacco leaves, creating a marinade that fermented and cured the tobacco inside the stump. Several times during curing, the natives removed the weight and extracted the leaves to air them, then returned them to the container and applied further pressure. Chenet is said to have modernized the process by substituting wooden boxes for hollow stumps, and adding a frame by which to enhance the delivery of pressure.

An alternate story about the origin of perique contradicts the legend, suggesting instead that Spanish colonial explorers had discovered natives of Hispañola curing tobacco in this way in the sixteenth century. Upon their return to Spain, they introduced both the product and the curing technique to the European market. This story has led some scholars to suggest that Chenet's Choctaw

and Chickasaw role models may have been using a process carried to Louisiana by early European settlers. Regardless of its origins, the method of processing perique has remained virtually the same for two centuries, with only minor changes. Later in the nineteenth century, for example, farmers began using ballast rocks to weigh down the lids of the fermenting boxes. (Used to provide stability for ships on open water, these stones were off-loaded when boats sailed into the Mississippi River.) In the 1920s heavy-staved oak barrels replaced curing boxes, and screw-jacks operated by muscle power were introduced to create pressure. Nevertheless, fermenting tobacco was—and continues to be—extracted by hand from its containers and laid out on boards to air a couple of times during its processing. A visitor to a perique shed in 1892 described the tobacco as resembling twisted rope, "looking like a section of weather-beaten Atlantic cable."

When the business began to expand in the late nineteenth century, the barrels of perique were hauled to dealers in early fall, placed under yet further pressure, and left to cure for months or years, depending on the desired strength of the resulting product. Similar tobaccos, especially Kentucky-grown, would be blended in according to the specifications of buyers. (Because of the full body of processed perique, it was commonly added to other tobaccos for aroma and flavor, only rarely used "straight.") The first dealers in perique were located in New Orleans, but by the early twentieth century, three St. James Parish men—Farrell Roussel, Joseph Francis

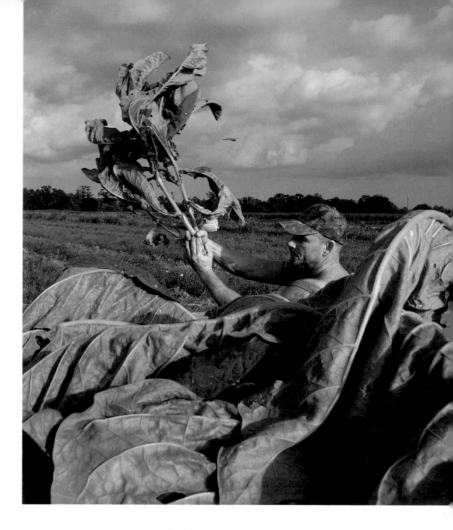

ALL STALKS ARE COLLECTED, LARGE AND SMALL.

ANTIQUE PERIQUE TIN

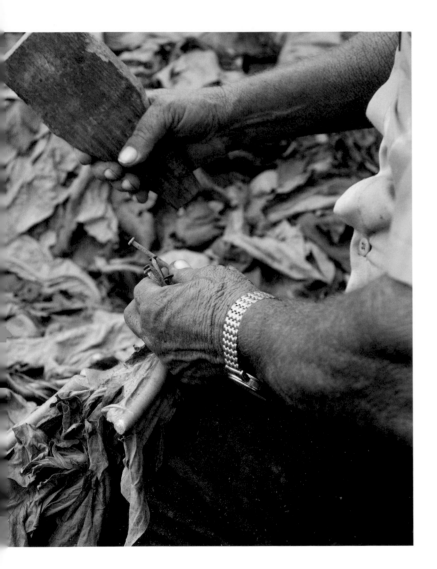

NAILS ARE HAMMERED INTO THE STALKS.

Guglielmo, and Louis Aristee Poché—had developed their own companies to compete for the business. Soon these local concerns dominated the trade and competed with one another for farmers and customers. Poché Company letterhead from 1937 names offices in both New Orleans and Convent, Louisiana, (up the road from Belmont and Paulina) and touts "large storage facilities for those who wish to buy in advance to protect against crop failure," reflecting the growth of the industry. Orders for perique came from across the country and the world: New York, Boston, San Francisco, Germany, Sweden, the United Kingdom, and beyond.

In comparison to sugarcane, the dominant River Road agricultural product, perique has always been a tiny crop. Even during its best years, from the 1920s to the 1950s, just over a thousand acres were planted in perique, while twenty-five thousand acres were planted in sugarcane. But it was a distinguished enough product—and a colorful enough story—that the venerable *Saturday Evening Post* devoted a lengthy article to perique in 1955, noting that no other tobacco was as expensive or demanded such labor-intensive cultivation. These two features would soon prove detrimental; indeed, the *Post* article proved to be a swan song of sorts. By the late 1960s, only twenty-five farmers were planting perique, and by 1979 land planted in perique had been reduced to only one hundred fifty acres.

Many factors may have contributed to the decline. The 1964 surgeon general's warning about the ill effects

of tobacco affected American attitudes about all forms of smoking. By the late 1960s many younger members of perique-growing families had exercised their preference for work in nearby chemical plants rather than in the fields, or had joined many longtime farmers in growing only soybeans, sugarcane, and other crops. A scholarly article analyzing the perique business in 1970 identified its labor-intensive cultivation and high international tariffs as factors that contributed to an unsustainably high price.

By the late 1980s, the perique business had contracted so dramatically that Roussel and Guglielmo closed their offices, leaving L. A. Poché as the sole dealer in perique. By the 1990s only one full-time perique farmer could be identified. Others who continued to plant small crops did so more to sustain the tradition than to make a living. "We promised our father we would," explained one St. James Parish farmer who spent his forty-hour work week as a banker. It seemed that Pierre Chenet's enterprise was on the verge of extinction.

And then, serendipity happened.

In a desperate attempt to save his business, the last full-time perique farmer mailed samples to an array of potential buyers and caught the fancy of Santa Fe Tobacco, a small company in New Mexico. In 2000 the company began buying perique for use in specialty cigarettes. This was not an entirely new application; though the tobacco has traditionally been used in pipe blends, perique is rumored to have been the secret ingredient that gave the legendary Picayune cigarettes their kick.

Picayune, which called itself the pride of New Orleans, was a brand of extremely strong cigarettes produced by Liggett and Myers and popular with adventurous smokers from the late nineteenth century until the 1960s.

A second fortuitous event for the continuation of the perique tradition was the arrival of another outsider. In 2005, a tobacco man from North Carolina purchased the failing L. A. Poché Company and its facilities. The new buyer knew nothing of Pierre Chenet or the perique legend but happened to own a successful tobacco company with a state-of-the-art operation and sensed an opportunity. He began to introduce some of the remaining local farmers to best practices: coating seeds to optimize planting, utilizing hydroponic greenhouses for easier transplanting, testing pH levels in the fields to cut fertilizer costs, and more. He hoped to stimulate more farmers to grow more acreage, knowing it takes approximately one thousand plants to yield six hundred pounds of raw leaf or four hundred pounds of processed, fermented, and packed perique. And, in what some considered heresy, he even sought to attract farmers on the west bank of St. James Parish to plant perique. Since the Mississippi River had wandered across the landscape through the millennia, he theorized, and if part of the secret of growing perique was in the soil, why wouldn't the soil on both banks be similar?

In 2009, in perhaps the most dramatic break with tradition, the new owner of L. A. Poché Perique Tobacco offered to buy the dried tobacco leaves direct from

farmers, to assume responsibility for all stripping and curing the leaves at his Convent plant. Although this lowered the price farmers would receive for the crop, it also removed their most laborious steps. This arrangement was mutually beneficial because a new federal law now required that tobacco processors be licensed; any farmer with a few barrels of fermenting perique who had not endured the labyrinthine procedure required to gain a federal permit would risk having his product deemed illegal. The L. A. Poché complex was enlarged to include an expansive, air-conditioned building with receiving bays, refrigerated storage, and good lighting, ensuring updated, modern conditions for the workers who stripped tobacco and those who turned and blended it for an expanded season of nine months per year. Both new perique dealers had contacts in the national and international tobacco marketplace, which they tapped to tout perique. Their efforts created new sizzle for an old product, and tobacco-industry magazines began once again to feature perique, now with its updated story.

If Pierre Chenet were to return to St. James Parish today, there is much he would recognize. A familiar calendar still governs the cycle of planting, harvesting, and drying tobacco—work still done primarily by hand. The tasks of stripping and curing, though removed from family barns, also draw on age-old methods. In the Poché warehouse, a clutch of men and women sit before levees of chocolate-colored leaves as high as their heads. They pluck a certain number of leaves, crinkled like starched taffeta, from the pile, then tie them together in a bouquet. After an overnight wetting, leaves for pipe blends are peeled from the stems by hand and packed into oaken barrels. (Cigarette tobacco can be cured with the stems on.) High-quality blending tobaccos from Canada are also processed to be added for blending. The antique fermenting barrels, abstractly decorated with black stripes from decades of escaped tobacco juice, are lined up within wood frames in the barns. Each barrel is positioned beneath a muscular screw jack that requires two straining men to ratchet up the pressure. According to the tradition, the fermenting perique is still lifted by hand from the barrels, carried to boards, and aired before being returned to ferment in its containers.

Pierre Chenet would see that perique acreage is increasing once again. And he'd be pleased to note that some farmers are young, members of a rising generation drawn back to the old traditions by new enticements.

Of course, some dissonance is bound to arise when a two-hundred-year-old tradition undergoes change. Some express regret over the introduction of modern techniques and equipment to the venerable St. James Parish art of perique. But others hold a more optimistic view, knowing that because of the changes *le tabac de perique* will not disappear. Indeed, it has been given a new lease on life—and those who know its story can continue to tell it proudly.

YOUNG TOBACCO LEAF

RIGHT: THE TIPS OF CANE KNIVES ARE REMOVED SO THEY DO NOT TEAR THE TOBACCO LEAVES.

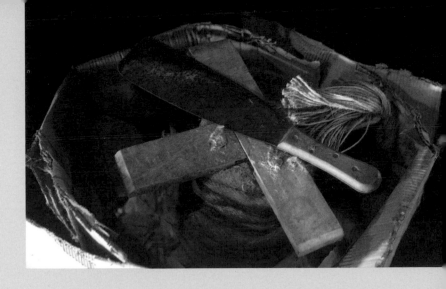

BIBLIOGRAPHY

Published Sources

Brennan, W. A. *Tobacco Leaves: Being a Book of Facts for Smokers*. Edited by Ross Brown. Menasha, WI: Collegiate Press / George Banta, 1915.

Burdeau, Cain. "Perique Farmers Buoyed by Increased Demand." *Advocate* (Baton Rouge), July 27, 2003.

Clark, Neil M. "The Tobacco That Bites Back." *Saturday Evening Post*, June 11, 1955, 47, 65–66.

DeGregorio, Jen. "Perique Has Made a Fiery Comeback Due to Outside Investors Who Are Breathing New Life into St. James Parish's Uniquely Pungent Tobacco." *Times-Picayune* (New Orleans), July 6, 2008. http://blog.nola.com/tpmoney/2008/07/perique_has_made_a_fiery_comeb.html.

Field, Martha R. *Louisiana Voyages: The Travel Writings of Catharine Cole*. Ed. Joan B. McLaughlin and Jack McLaughlin. Jackson: University Press of Mississippi, 2006.

Fuller, R. Reese. "The Last Perique Farmer." *Angola to Zydeco* (blog), August 21, 2002. http://www.reesefuller.com/articles/the-last-perique-farmer.

Godbee, Kevin. "The Mystique of Perique." *PipesMagazine.com*. January 3, 2010. http://pipesmagazine.com/blog/put-that-in-your-pipe/the-mystique-of-perique.

———. "Perique Tobacco Legacy of 50 Years—Curtis Hymel." *PipesMagazine.com*, March 21, 2010. http://pipesmagazine.com/blog/pipe-news/perique-tobacco-legacy-of-50-years-curtis-hymel.

Gray, Leonard. "Perique Tobacco Produced Sole[l]y in St. James Parish." *L'Observateur* (LaPlace, LA), October 2, 1998.

Hunter, Mark H. "Return of the Perique Farmers: Tobacco King's Children Pursue Family Tradition." *Advocate* (Baton Rouge), July 26, 2004.

Keyes, Frances Parkinson. *All This Is Lousiana*. New York: Harper, 1950.

Leffingwell, John C., and E. D. Alford. "Volatile Constituents of Perique Tobacco." *Electronic Journal of Environmental, Agricultural and Food Chemistry* 4, no. 2 (March/April 2005).

"Louisiana Grows Unique Tobacco." *Tobacco Observer* 4, no. 4 (August 1979): 2.

"Perique Harvest." *St. Jamesian* 1, no. 3 (Summer 1945): 19–24.

Rense, William C. "The Perique Tobacco Industry of St. James Parish, Louisiana: A World Monopoly." *Economic Botany* 24, no. 2 (April–June 1970): 123–30.

Tobacco Institute. *Louisiana and Tobacco: A Chapter in America's Industrial Growth*. Tobacco History Series. 1st ed. Washington, DC: Tobacco Institute, 1973.

Weber, Carl Borromed. *Weber's Guide to Pipes and Pipe Smoking*. New York: Cornerstone Library, 1962.

Zachariadis, Peter. "Louisiana Tobacco Has Place in World Market." *Advocate* (Baton Rouge), February 28, 1999.

Archival Sources

Louis Aristee Poché papers, 1937–1954. Louisiana and Lower Mississippi Valley Collections. Special Collections, Hill Memorial Library, Louisiana State University, Baton Rouge.

Personal Interviews

Guidry, Kenneth (LSU Agricultural Extension Service, St. James Parish). May 20, 2011.

Hymel, Curtis (L. A. Poché Company). June 21 and 29, 2011. Convent, LA.

Martin, Grant. June 5, 2011. Grand Point, LA.

Ryan, Mark (L. A. Poché Company). June 29, 2011. Convent, LA.

PHOTOGRAPHS BY CHARLES MARTIN

Planting beds are protected with wooden frames and plastic sheeting. Here, new beds are prepared.

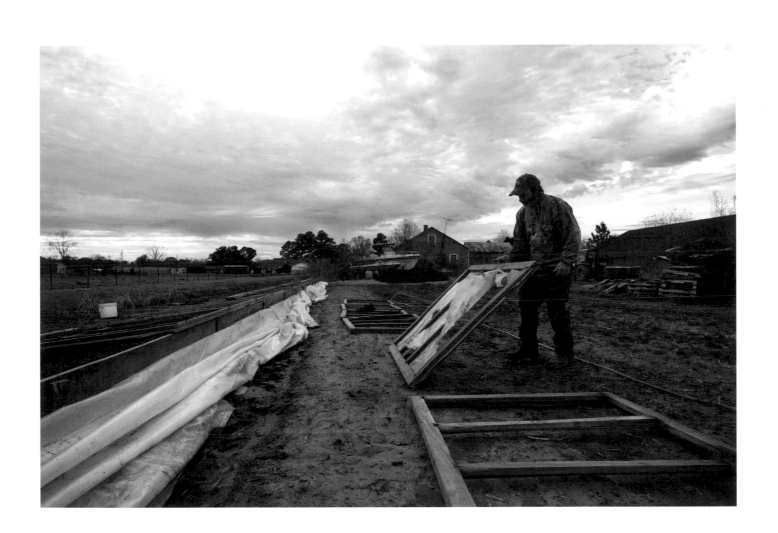

Old frames are stripped and covered with new plastic.

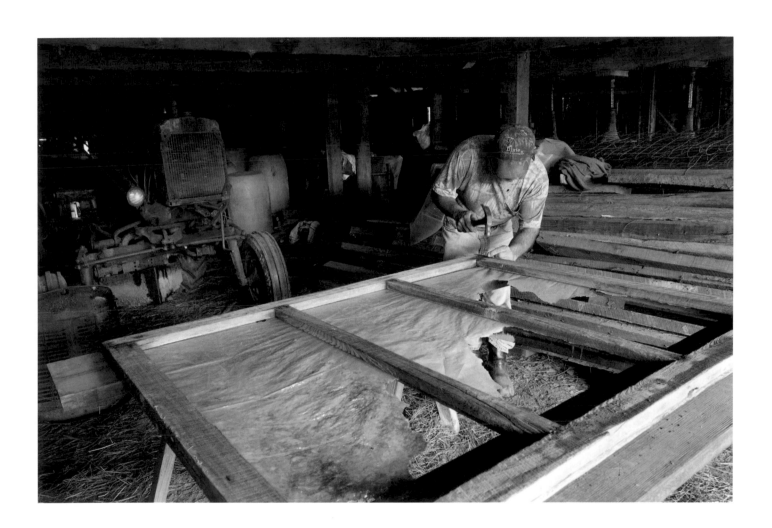

Ashes are sifted in preparation for seeding.

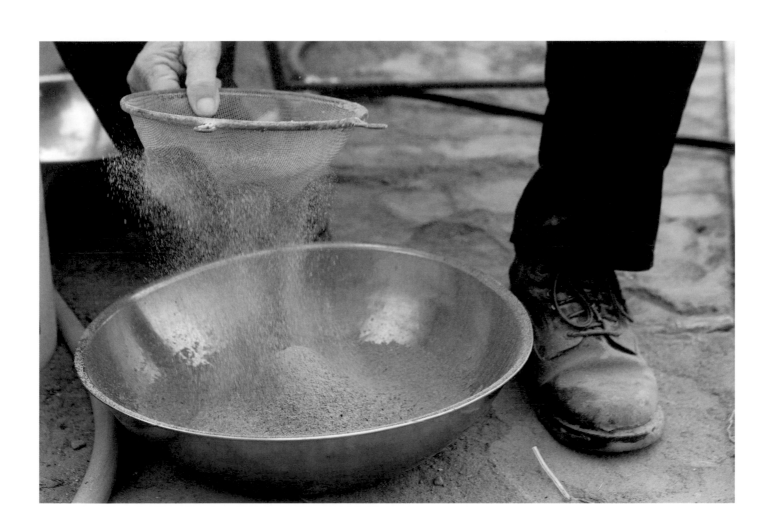

Perique seeds are so small, a single thimbleful will plant
nearly an acre of tobacco. When mixed with ashes, as seen here,
they spread easily and evenly.

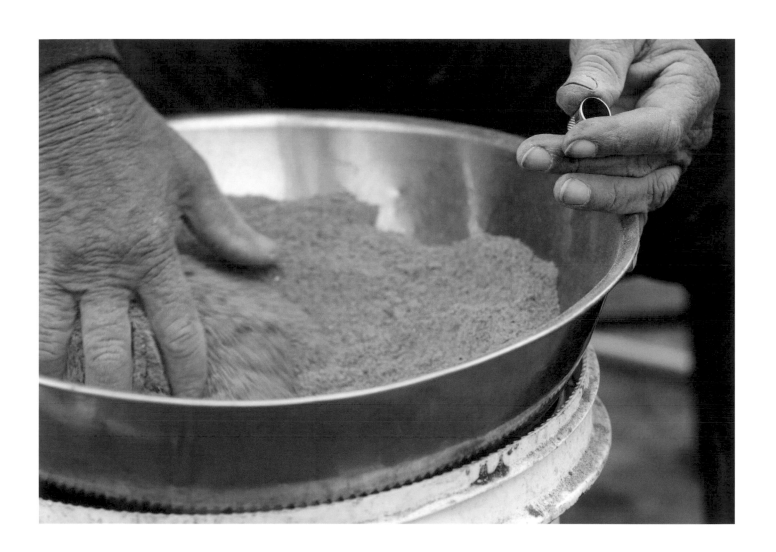

The ash and seed mixture is spread by hand.

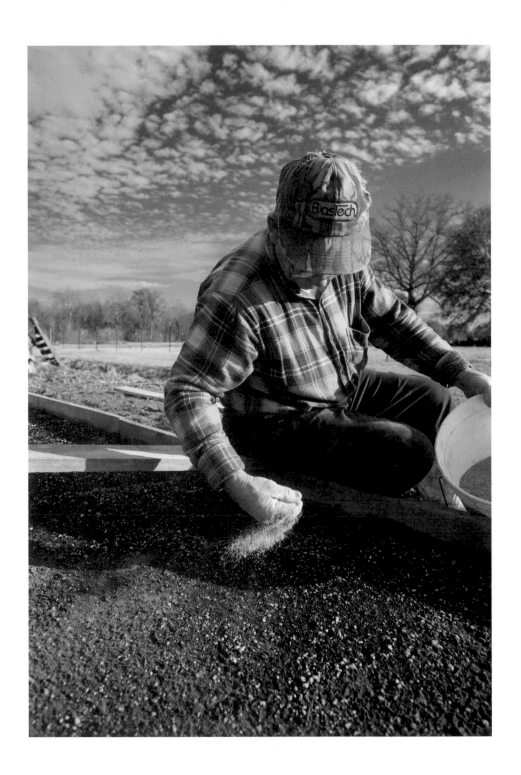

Tin cans are used to prop the frame lids open during the day, to regulate temperature.

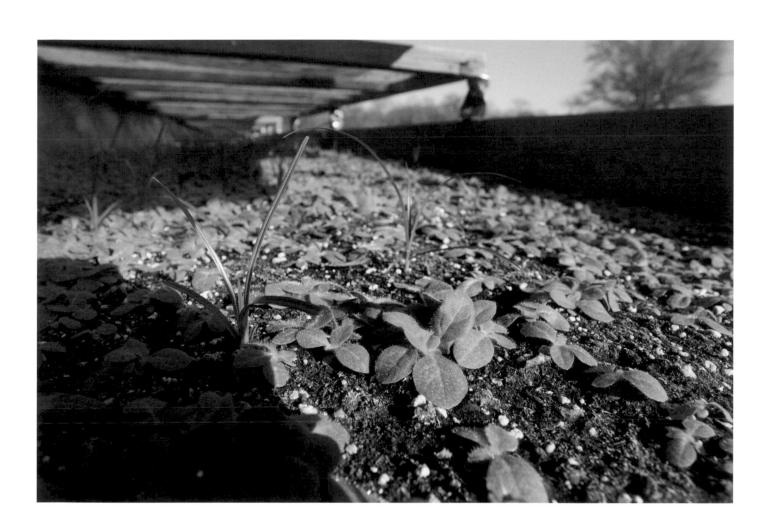

Weeks-old seedlings are collected for transplanting.

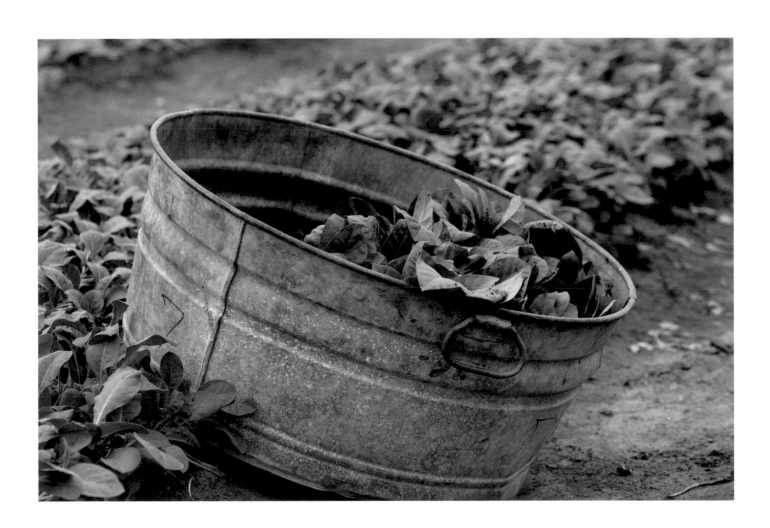

The seedlings are separated before planting.

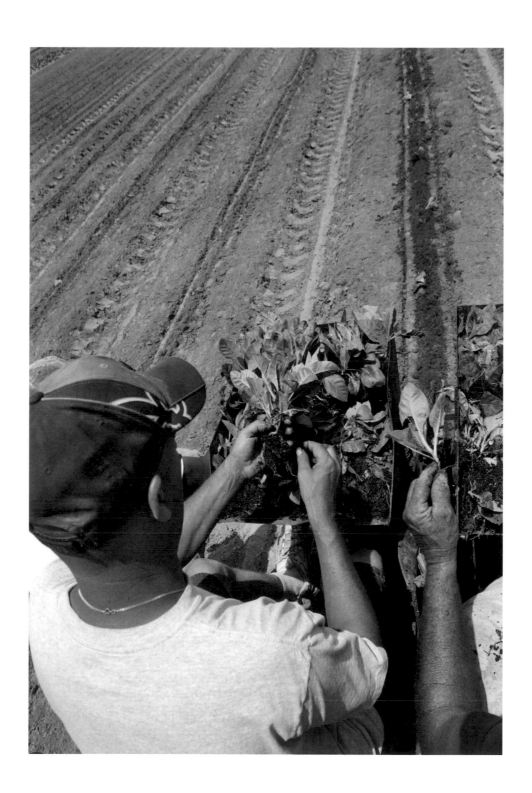

Each seedling is given plenty of room to grow, planted about
three feet apart.

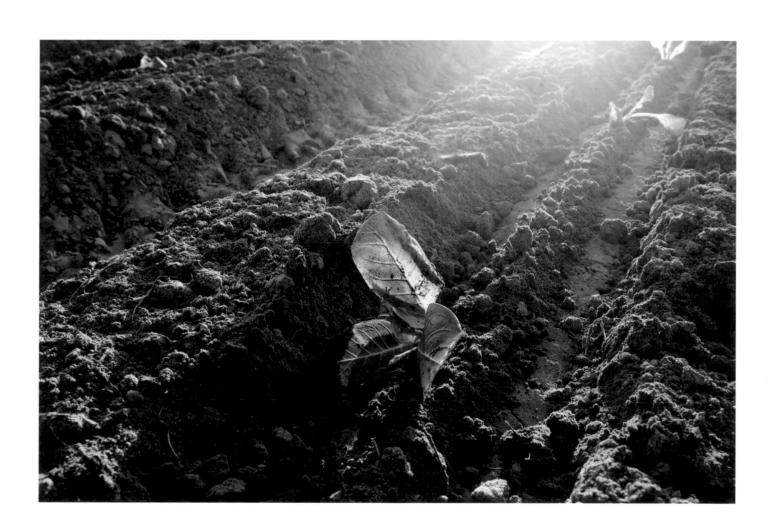

Traditionally, crops were only as successful as the weather
allowed, but modern planters will use irrigation as a last resort
during dry spells.

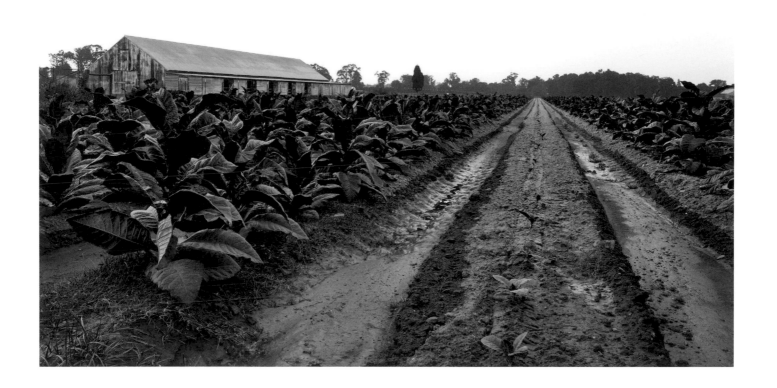

The smaller leaves, or "suckers," between larger leaves are broken off to create a stronger plant.

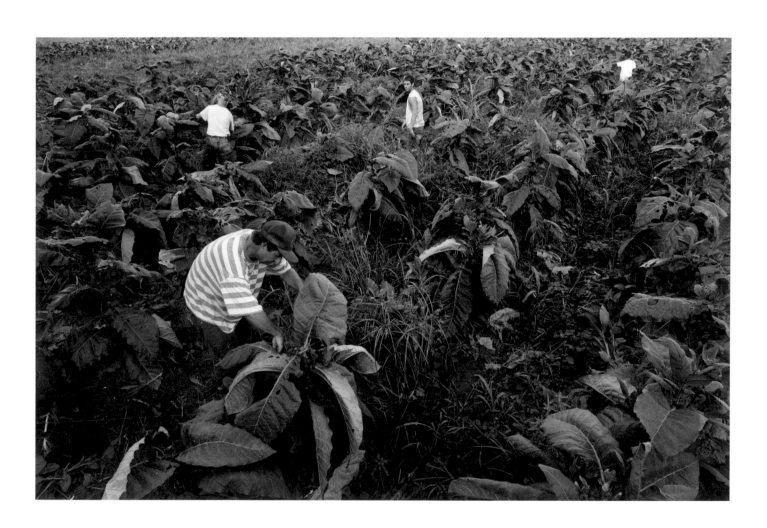

Lingering suckers are broken off a full-grown plant before harvesting.

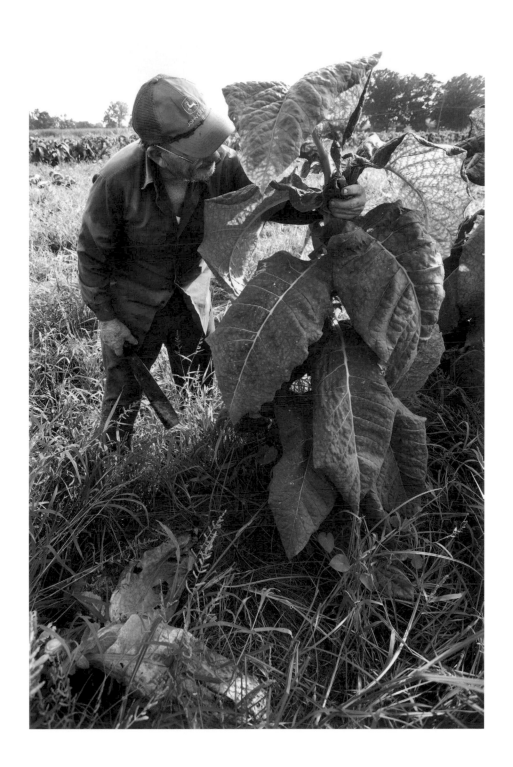

At harvesttime, stalks are cut and carefully placed on the ground.

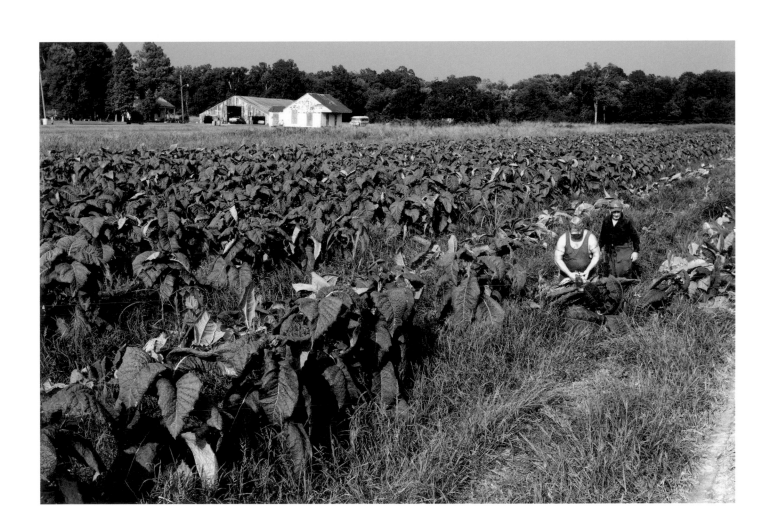

After being left to wilt for a few hours, the heavy stalks are
collected with a wagon called a cot.

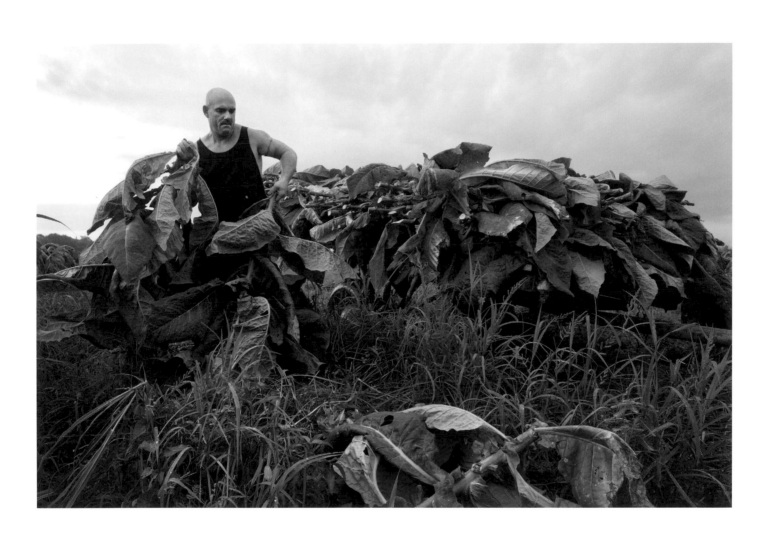

Stalks are stacked in an alternating pattern to distribute the weight and avoid breakage.

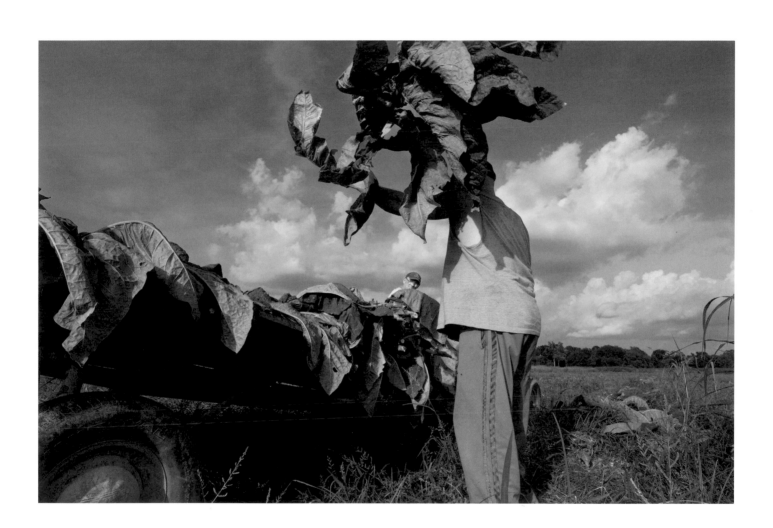

If cots are overloaded, the leaves will be crushed under their own weight. Many trips must be made into the fields to collect the tobacco.

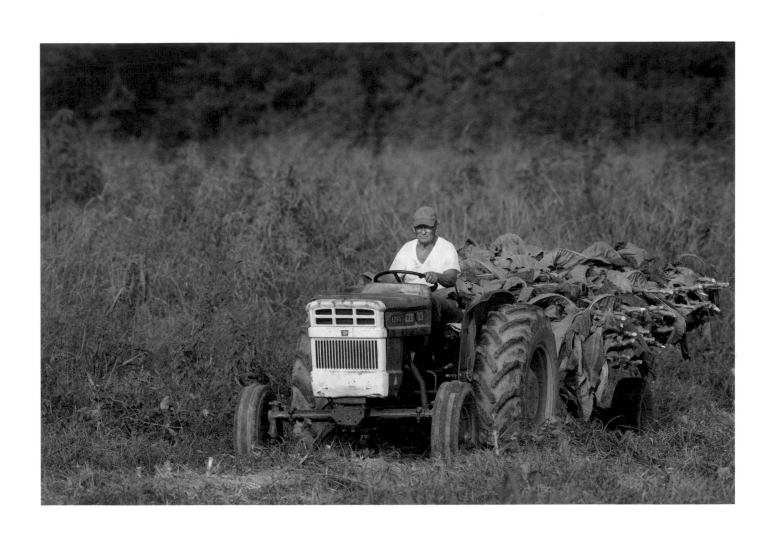

A load is slid off the cot, slowly and steadily, onto a clean tarp.

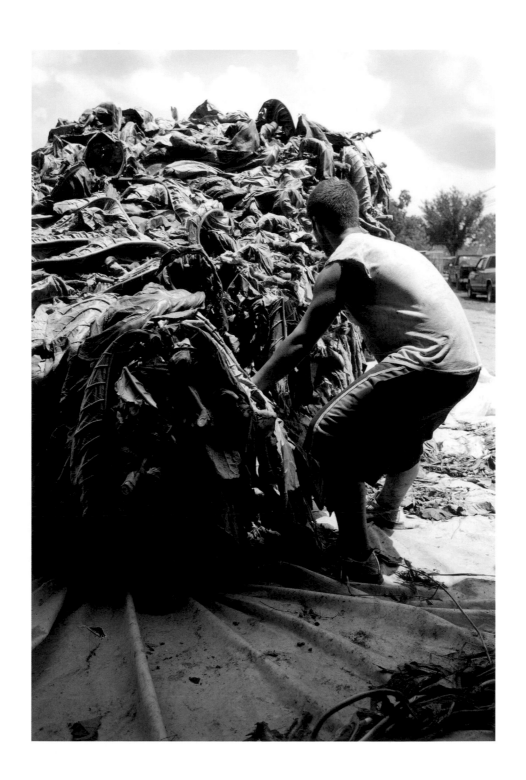

Handmade wooden mallets called copcops are used to drive
nails into the fresh stalks, which will be hung to dry.

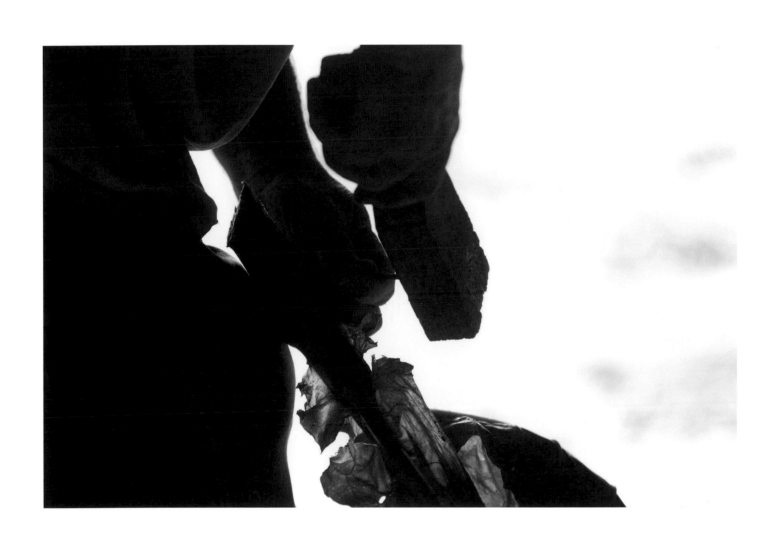

A well-made copcop will last for years and is an integral part
of the perique process.

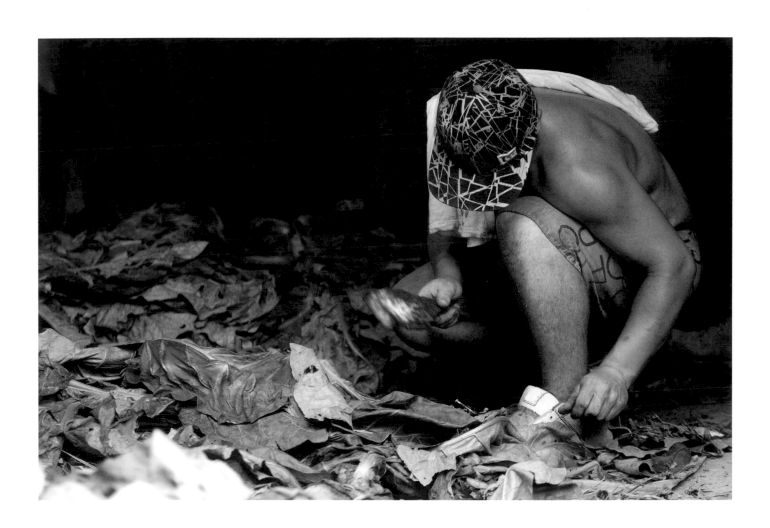

Each nail must be positioned at a forty-five-degree angle two
inches from the end of a stalk.

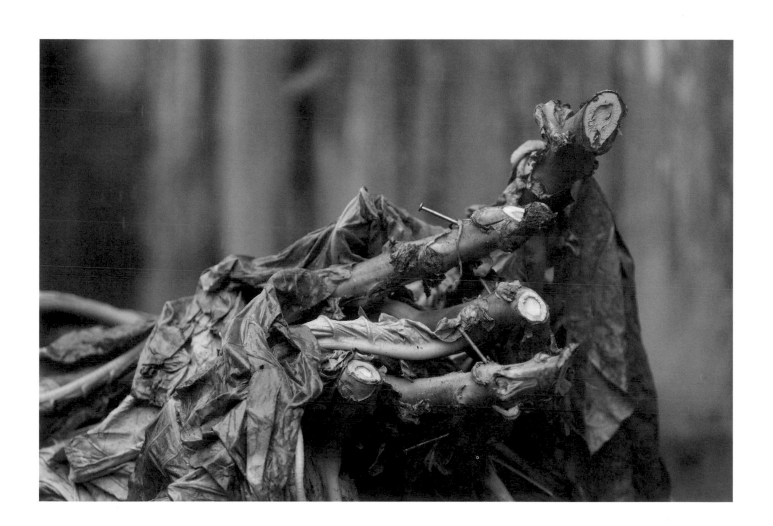

Most perique barns are two stories high, and tobacco is hung
on both levels.

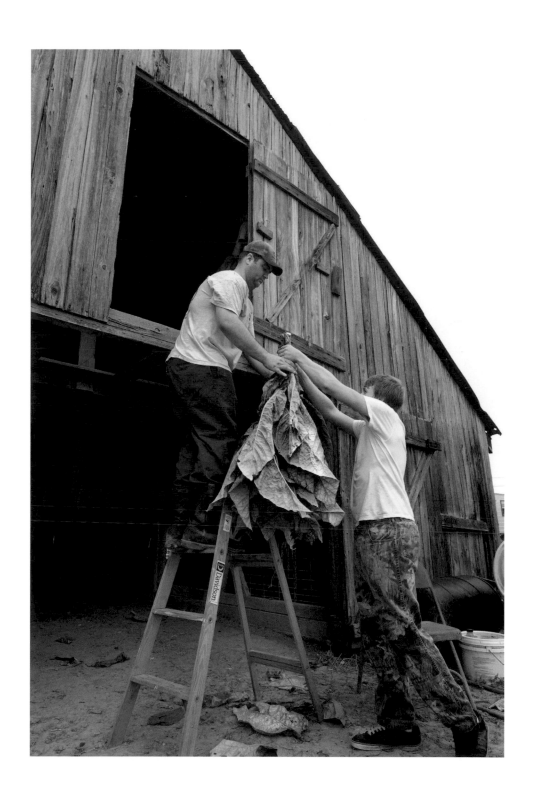

Stalks must be placed carefully: close enough to not waste space but far enough apart to prevent mildew.

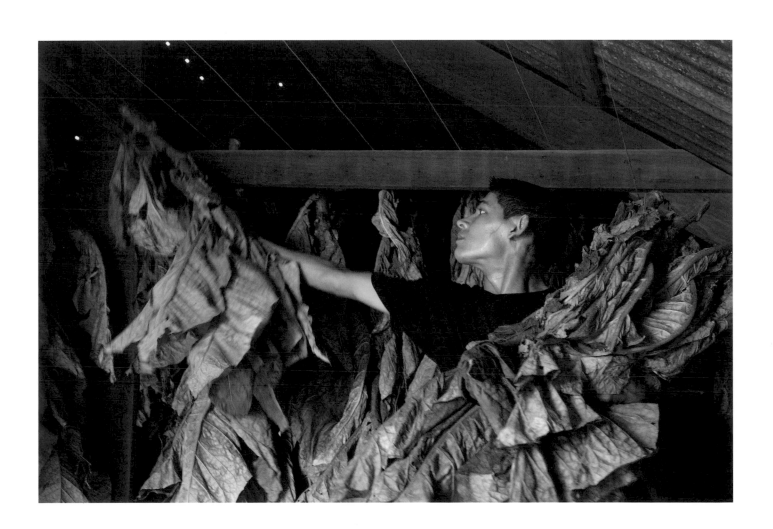

The harvest is a community affair.

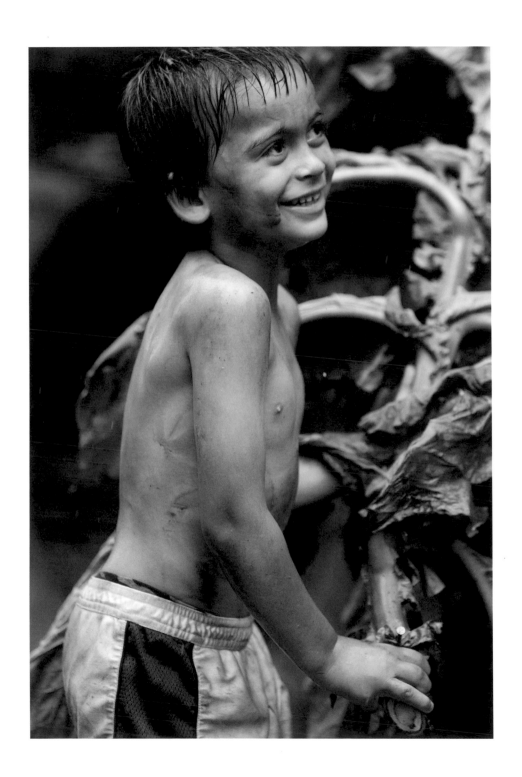

Perique dries for a few weeks.

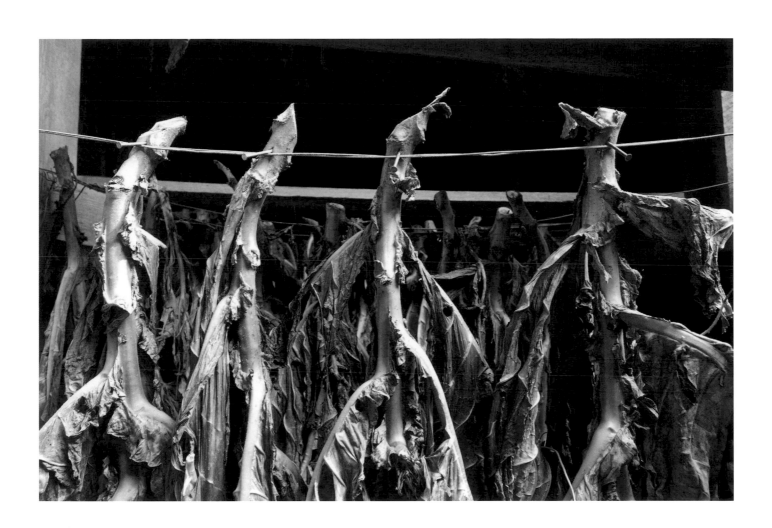

As the tobacco dries, it is moved around the barn: fresher stalks are given more room; older, more wilted ones can be hung closer together.

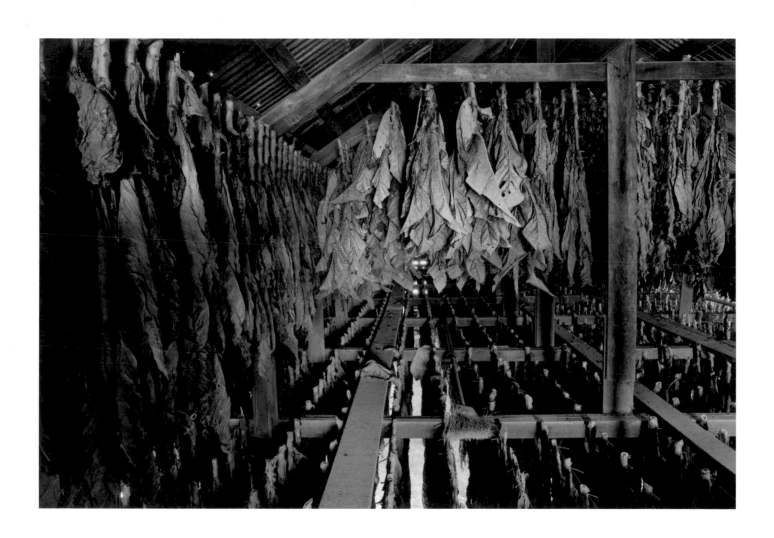

No space is wasted in a perique barn. Often, there is just enough room for the cot to pass through without damaging the surrounding stalks.

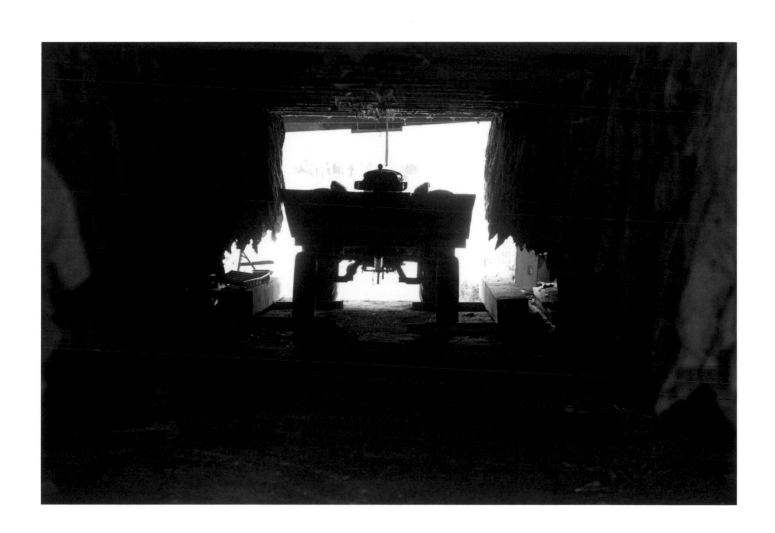

The wilted leaves are pulled off the stalks.

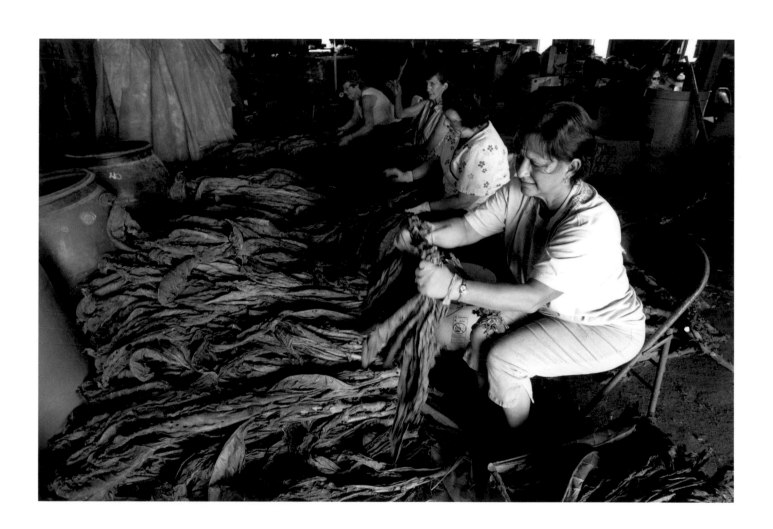

Leaves are beaten gently on metal drums to remove dirt and dust.

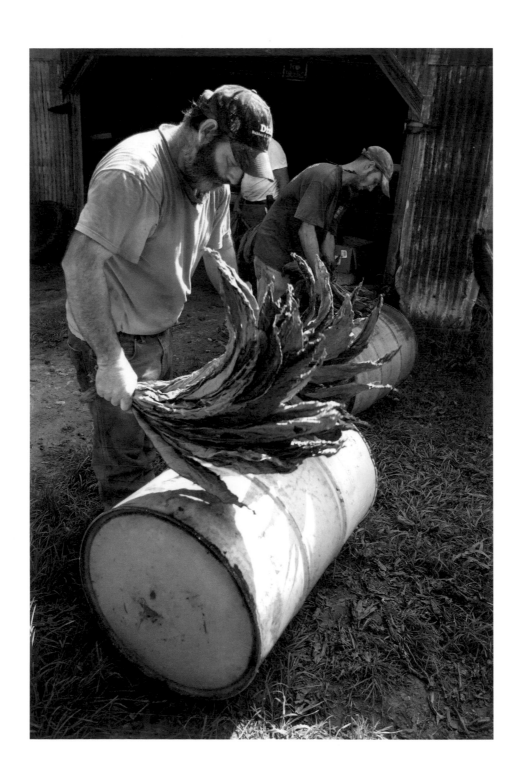

Clipping is the process by which the fattest part of the leaf stem, which can hold water and ruin the tobacco, is removed.

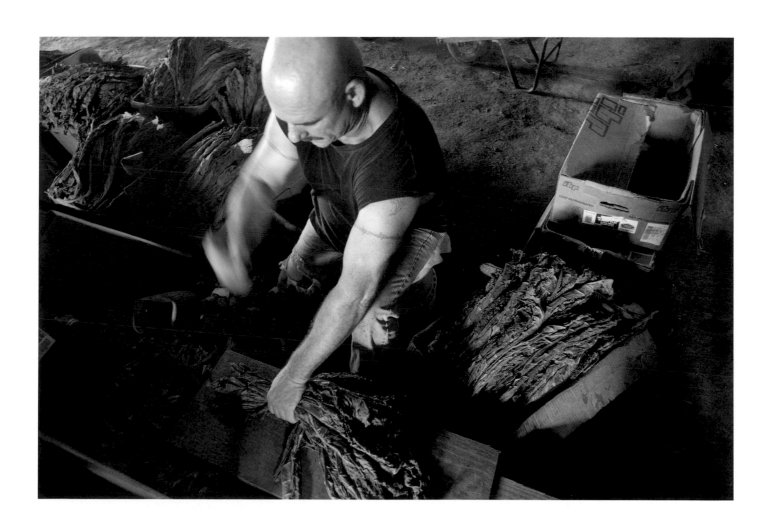

Sugarcane knives or machetes are used for clipping.

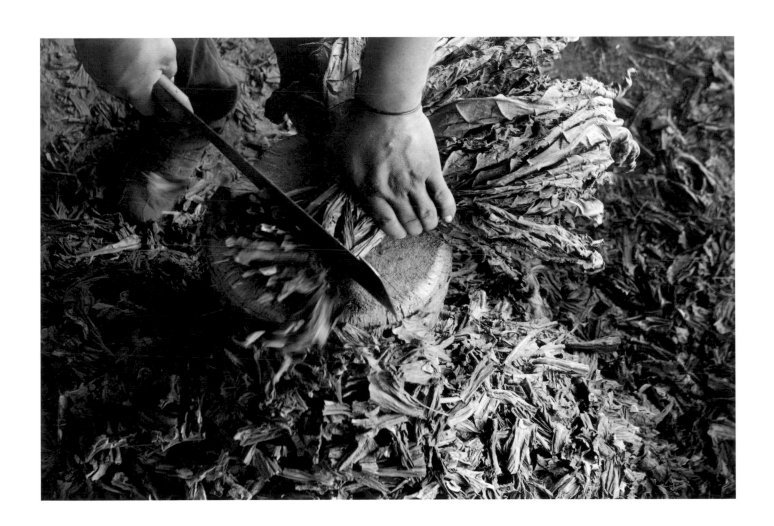

Leaves are lightly dampened before packing to ensure the perfect level of moisture.

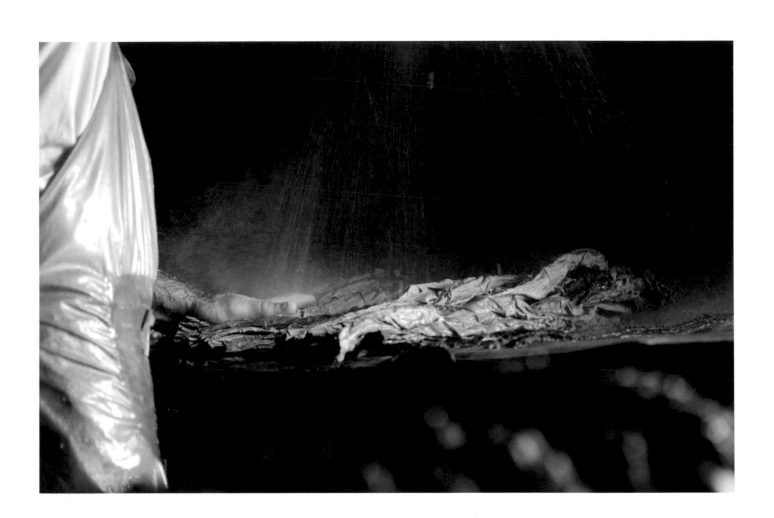

Leaves are tied into packs.

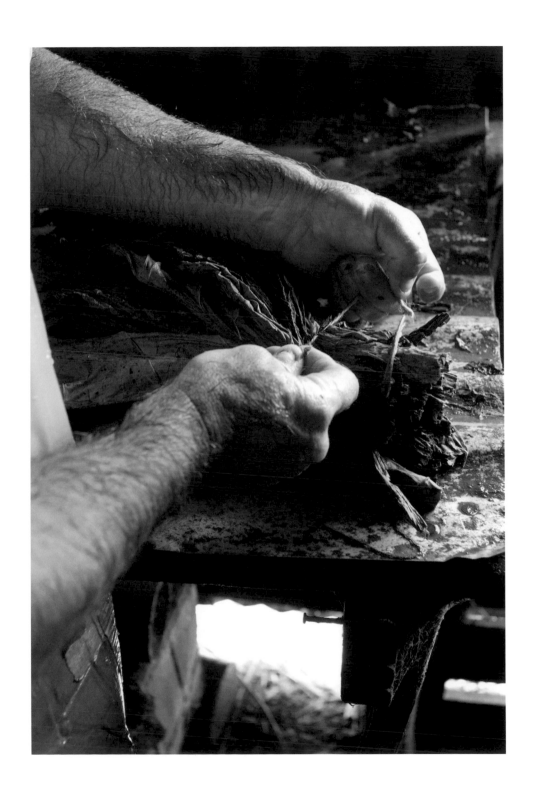

"Dressing the pack" is the traditional way of preparing perique, but extremely time consuming. The best leaves are used to wrap the packs, making them easy to handle and more attractive.

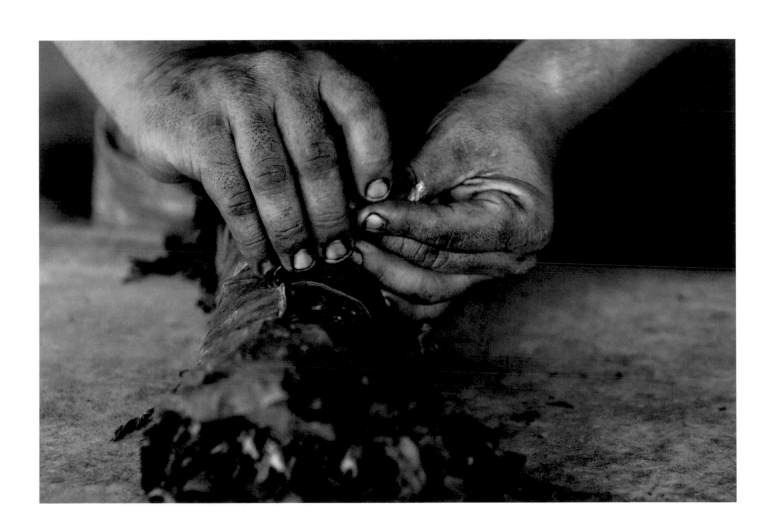

Old whiskey barrels, burnt and waxed, are packed with layers of tobacco.

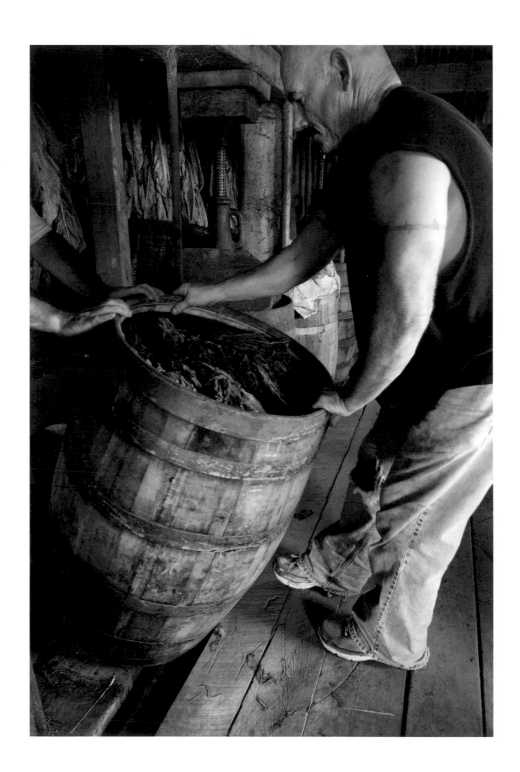

House jacks are used to create pressure in the barrels, where the tobacco ferments in its own juice. A couple of times during processing, the charges are removed, aired, and repacked.

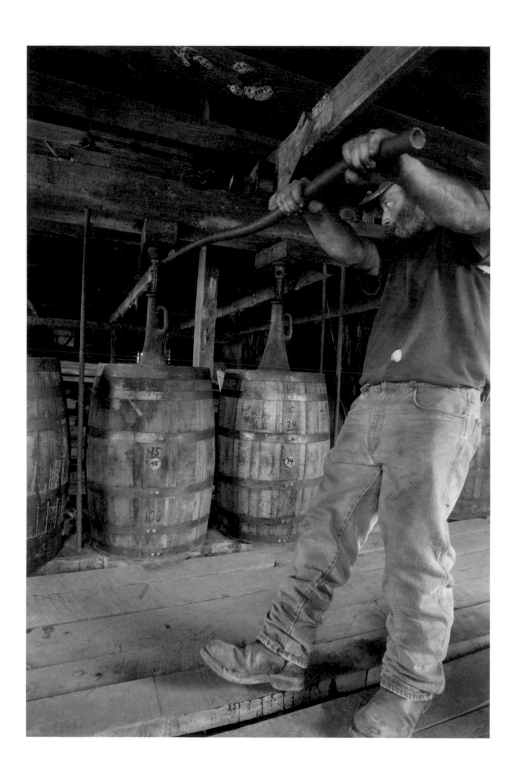

Barrels are marked with numbers indicating their weight and stage of fermentation.

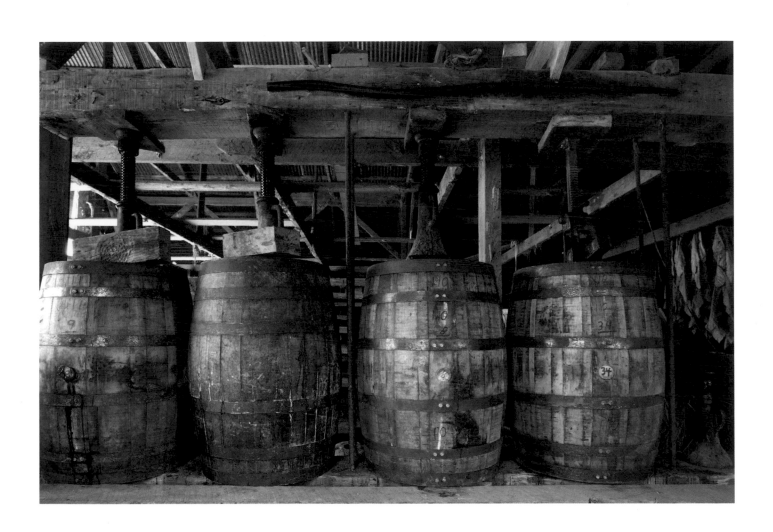

Barrels are lined with paper in preparation for
a final round of pressing.

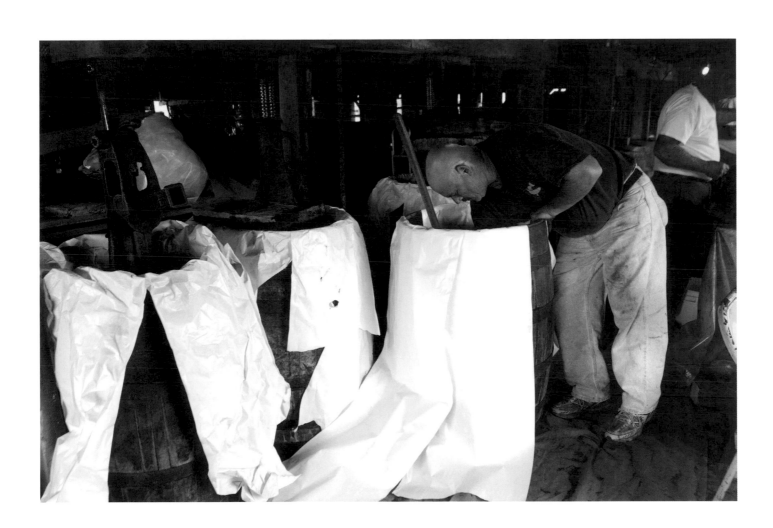

After a barrel is packed for the final time, its temporary
pressing lid is replaced with a permanent seal.

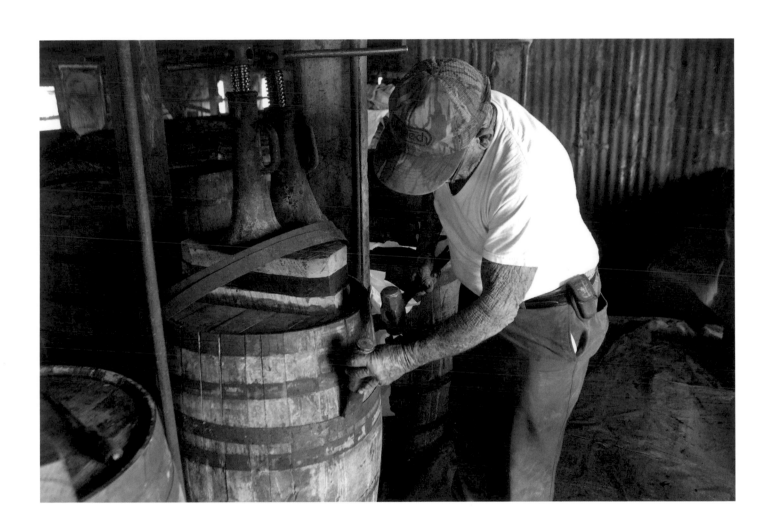

Constructed of cypress with a galvanized tin roof, this structure
is one of the few original perique barns that still stand.

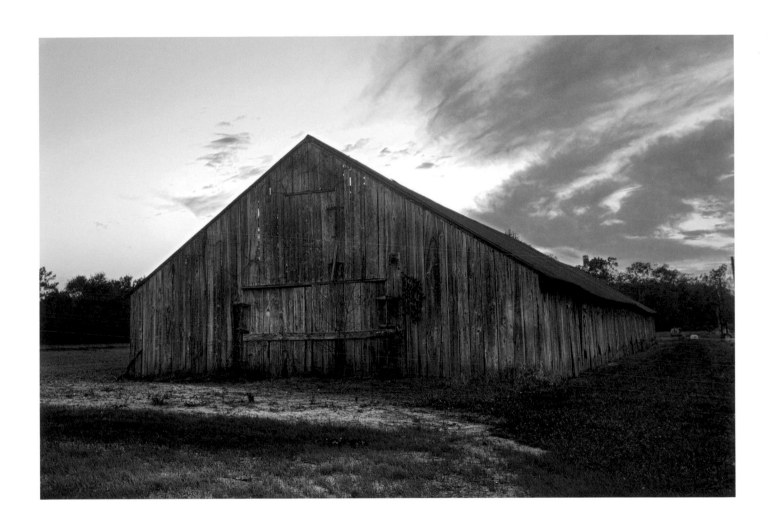

ACKNOWLEDGMENTS

Sincere gratitude for the perique farmers who allowed me to document their work. This book would not be possible without their cooperation and support. And to Laura VanHuss, for all her help.

— Charles Martin

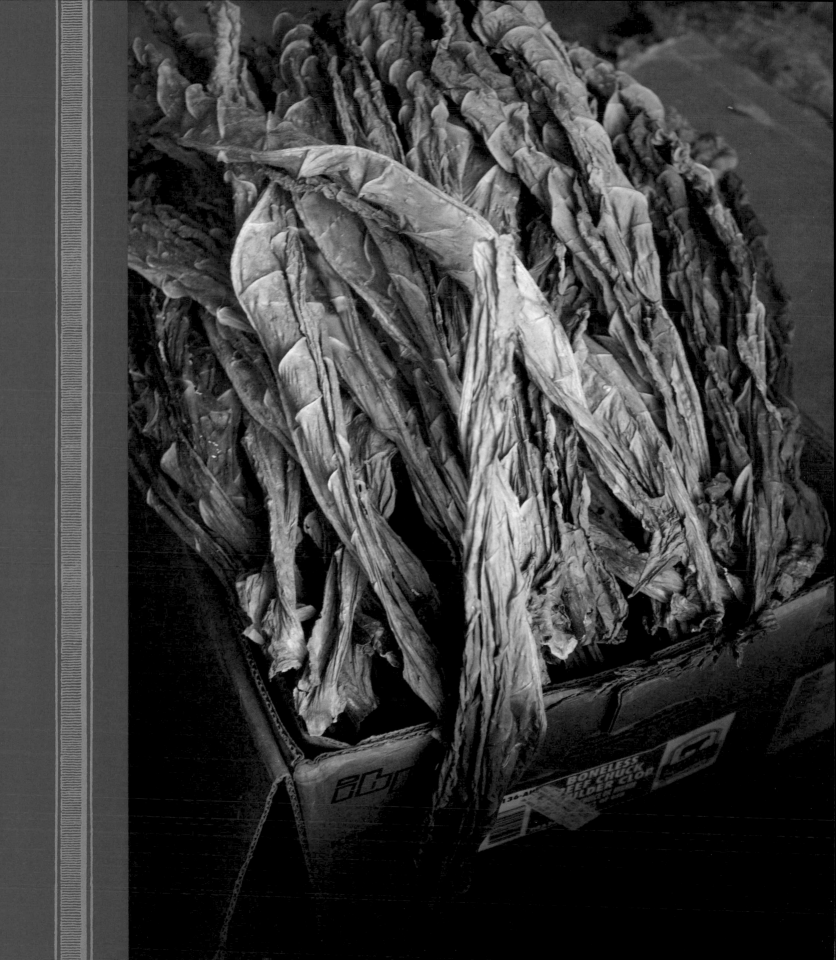